Art Nouveau Flowers and Floral Ornament

CD-ROM and Book

Edited by
GUSTAVE KOLB
and
CHARLES GMELICH

DOVER PUBLICATIONS, INC.
Mineola, New York

The CD-ROM in this book contains all of the images. Each image has been scanned at 300 dpi and saved in JPEG format. There is no installation necessary. Just insert the CD into your computer and call the images into your favorite software (refer to the documentation with your software for further instructions).

All of the graphics files are in the Images folder on the CD. The Images folder contains two different folders. All of the 300-dpi, high-resolution JPEG images have been placed in one folder and all of the 72-dpi, Internet-ready JPEG images have been placed in the other folder. Every image has a unique file name in the following format: xxx.JPG. The first 3 digits of the file name correspond to the number printed under the image in the book. The last 3 letters of the file name, "JPG," refer to the file format.

So, 001.JPG would be the first file in the JPEG folder.

Also included on the CD-ROM is Dover Design Manager, a simple graphics editing program for Windows that will allow you to view, print, crop, and rotate the images.

For technical support, contact:
Telephone: 1 (617) 249-0245
Fax: 1 (617) 249-0245
Email: dover@artimaging.com
Internet: **http://www.dovertechsupport.com**
The fastest way to receive technical support is via email or the Internet.

Bibliographical Note

Art Nouveau Flowers and Floral Ornament CD-ROM and Book, first published in 2007, contains all of the images from *Art Nouveau Flowers and Floral Ornament in Full Color,* by Gustave Kolb and Charles Gmelich, originally published by Dover Publications, Inc., in 2005, which, in turn, is a republication of all of the illustrations from *De la Plante à l'Ornement,* originally published by Jllig & Müller, Göppingen (Germany), in 1902.

Dover Electronic Clip Art®

International Standard Book Number: 0-486-99839-8

Manufactured in the United States of America
Dover Publications, Inc., 31 East 2nd Street, Mineola, N.Y. 11501

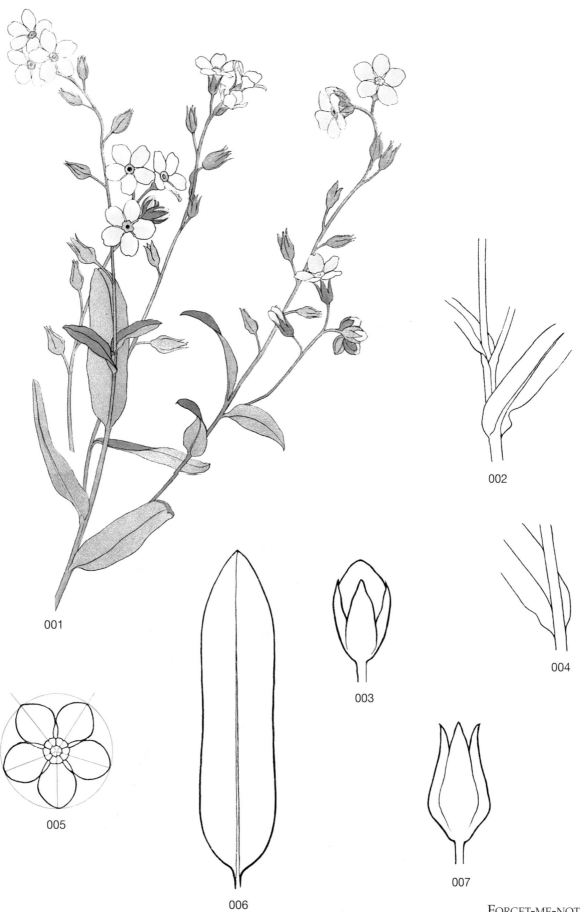

001

002

003

004

005

006

007

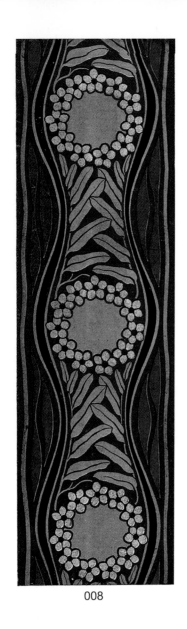

008

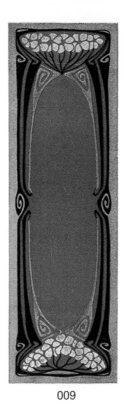

009

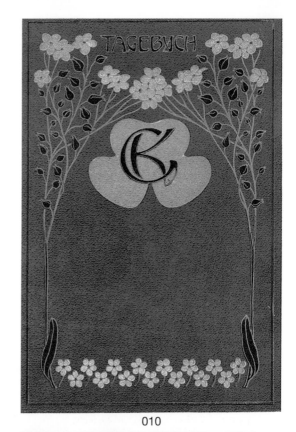

010

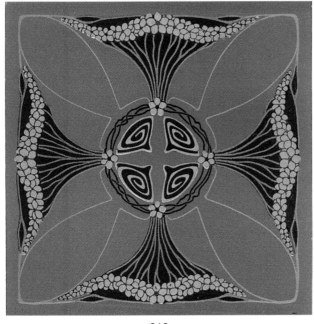

011

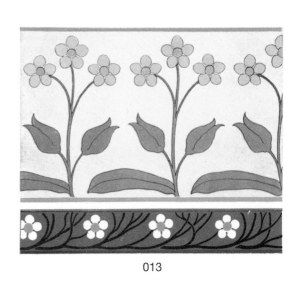

013

012

2 FORGET-ME-NOT

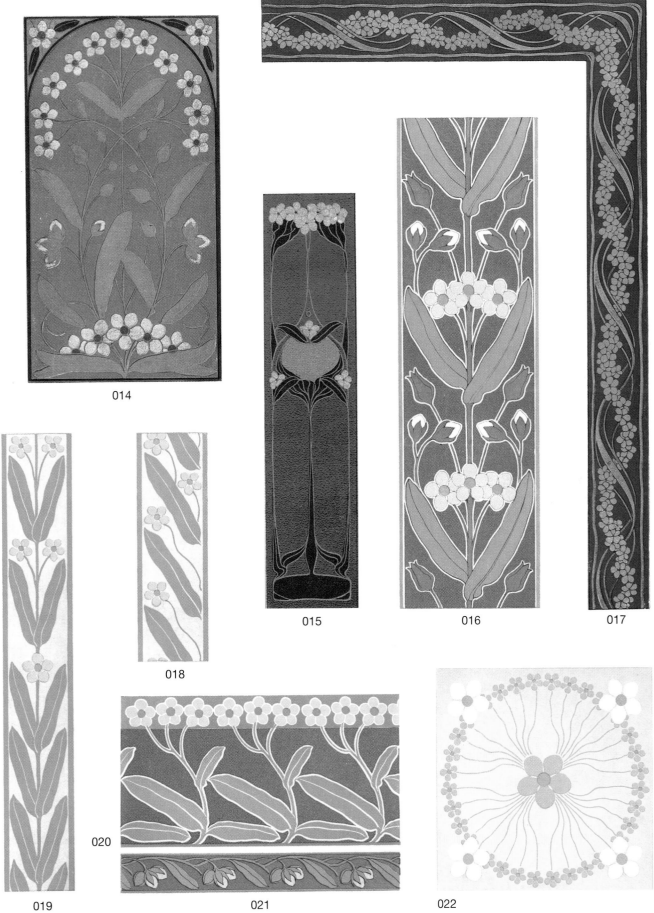

014

015

016

017

018

019

020

021

022

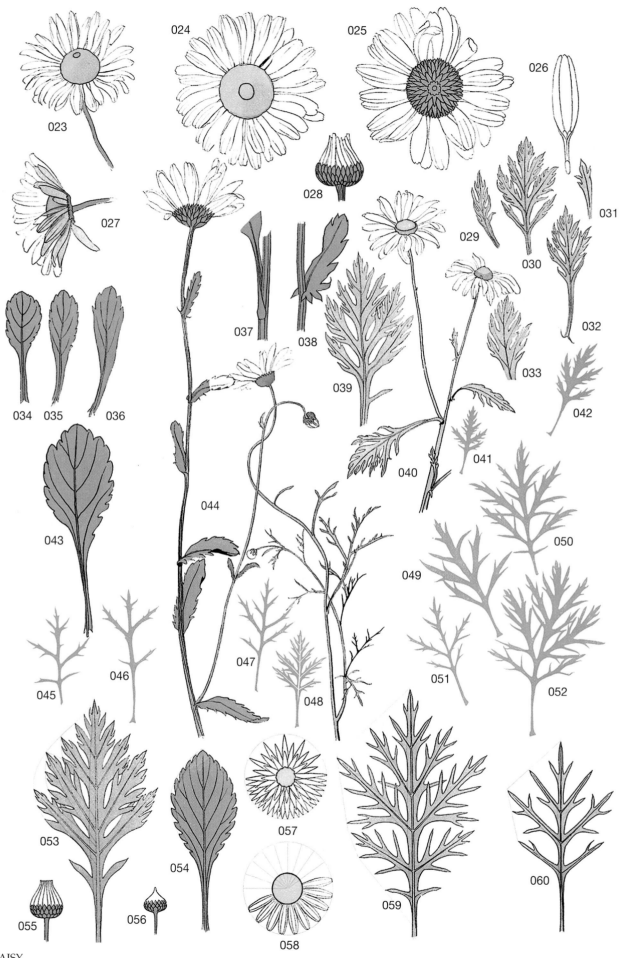

023

024

025

026

027

028

029

030

031

032

033

034 035 036

037

038

039

040

041

042

043

044

045

046

047

048

049

050

051

052

053

054

055

056

057

058

059

060

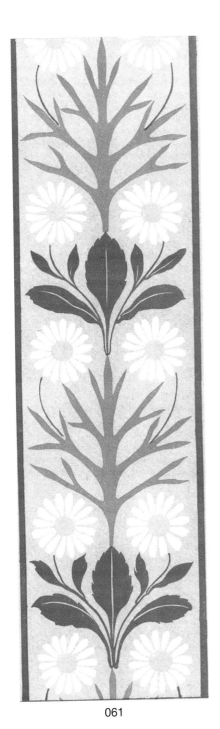

061

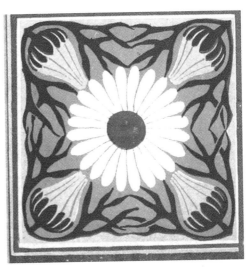

062

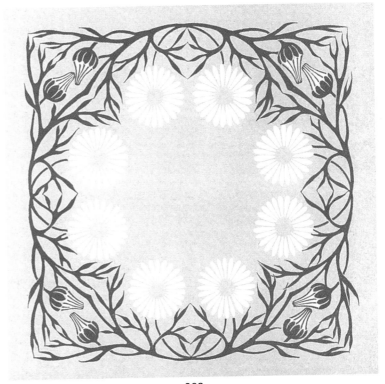

063

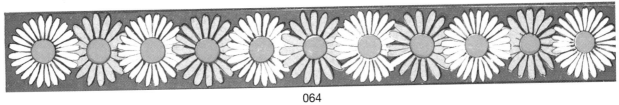

064

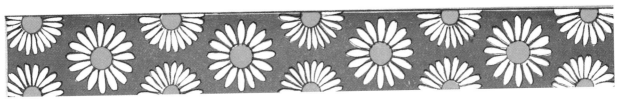

065

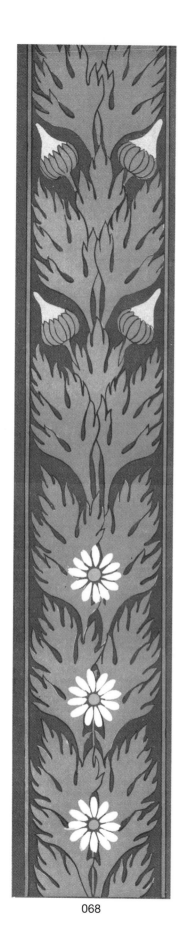

068

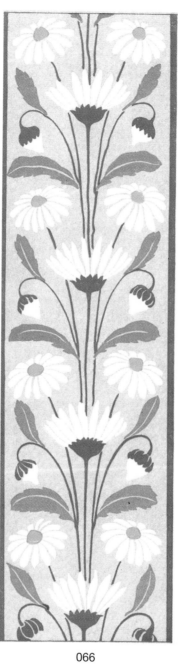

066

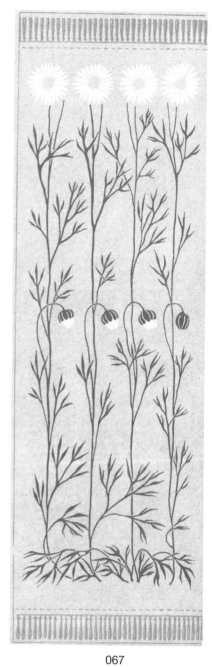

067

069

070

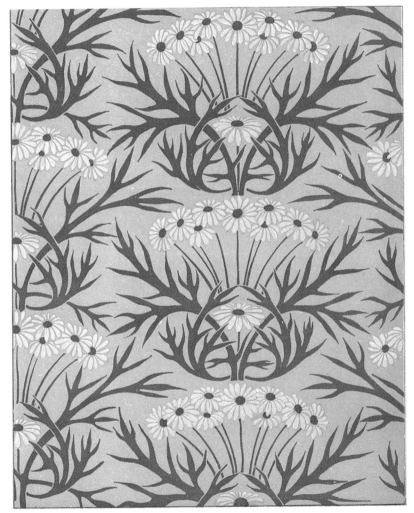

071

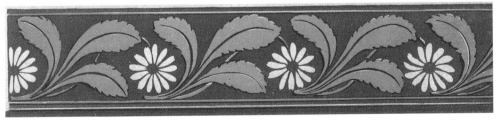

072

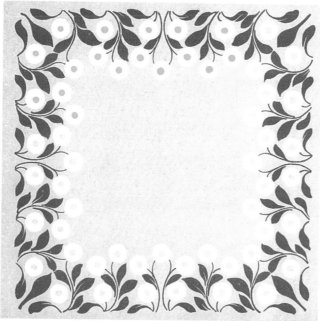

073

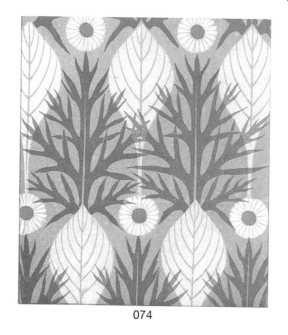

074

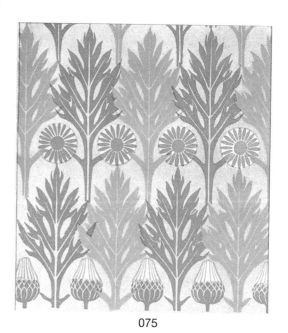

075

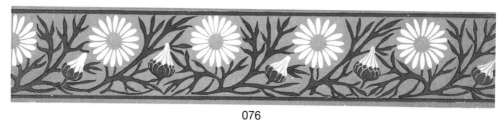

076

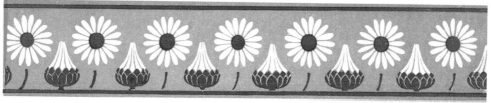

077

8 DAISY

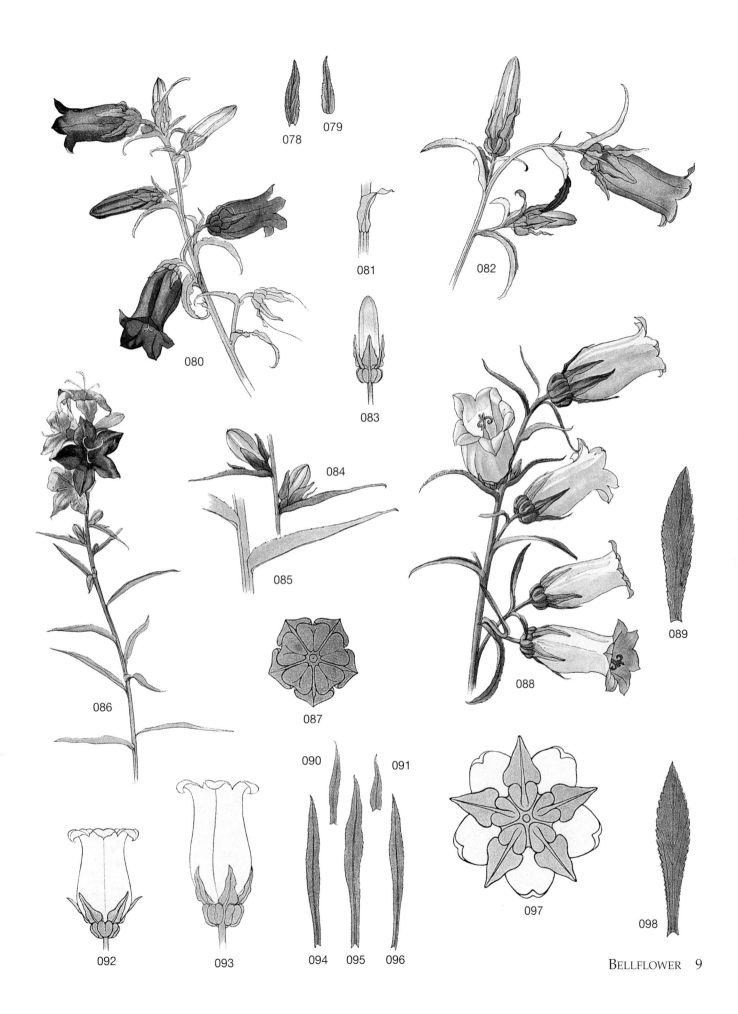

078

079

080

081

082

083

084

085

086

087

088

089

090

091

092

093

094 095 096

097

098

099

100

101

102

103

104

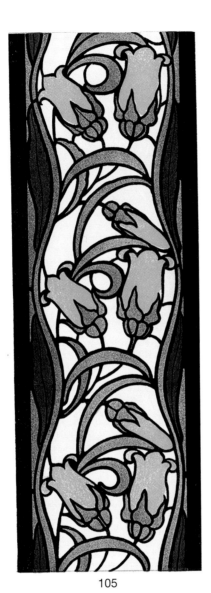

105

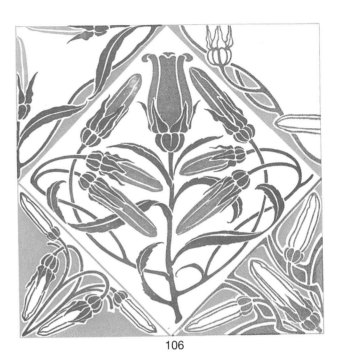

106

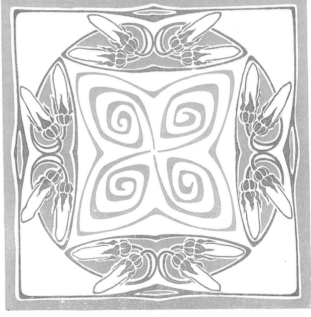

107

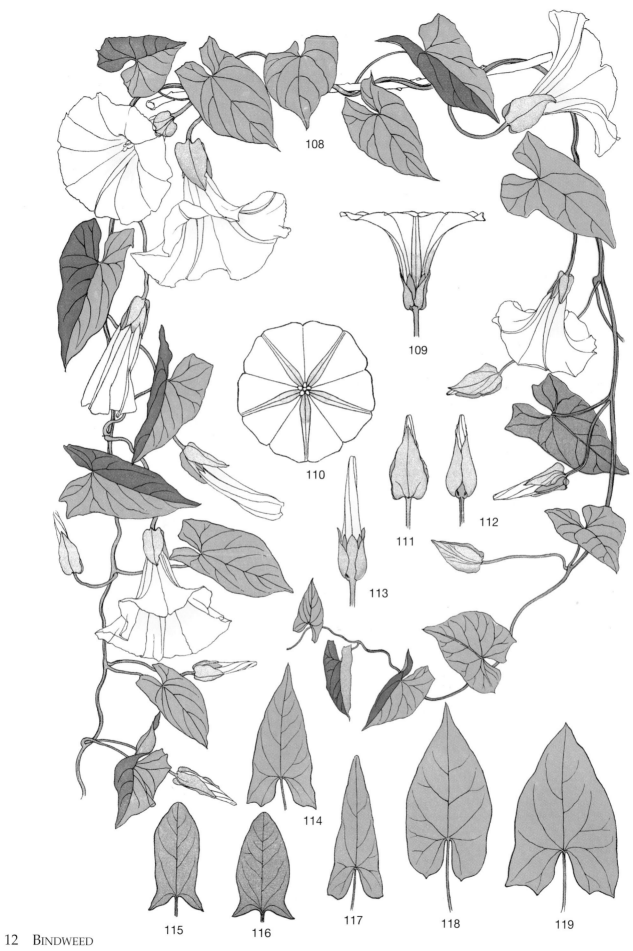

108

109

110

111

112

113

114

115

116

117

118

119

120

121

122

123

124

125

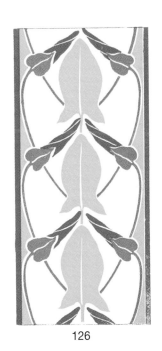

126

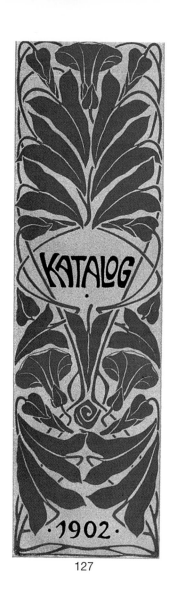

127

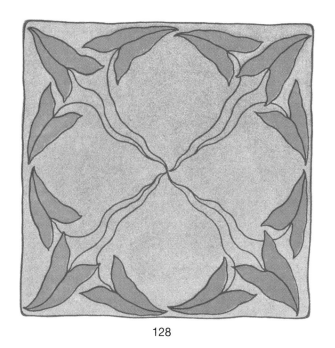

128

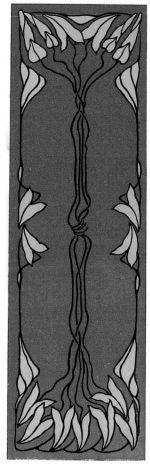

129

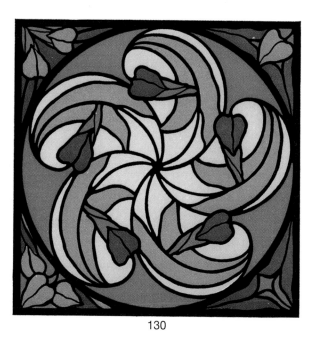

130

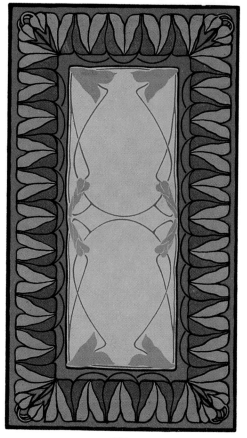

131

14 BINDWEED

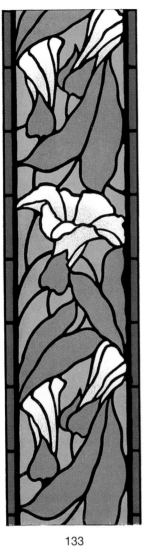

133

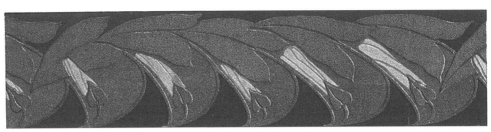

132

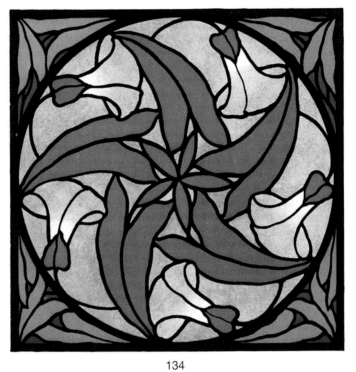

134

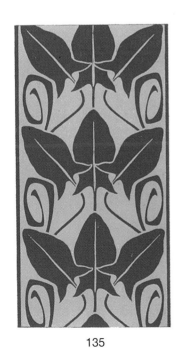

135

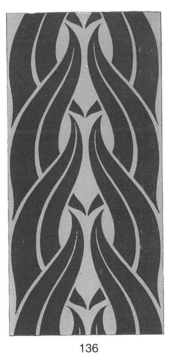

136

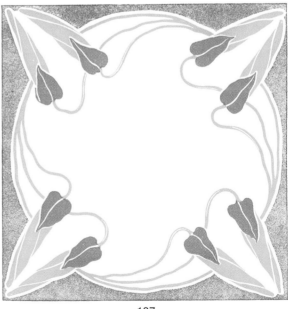

137

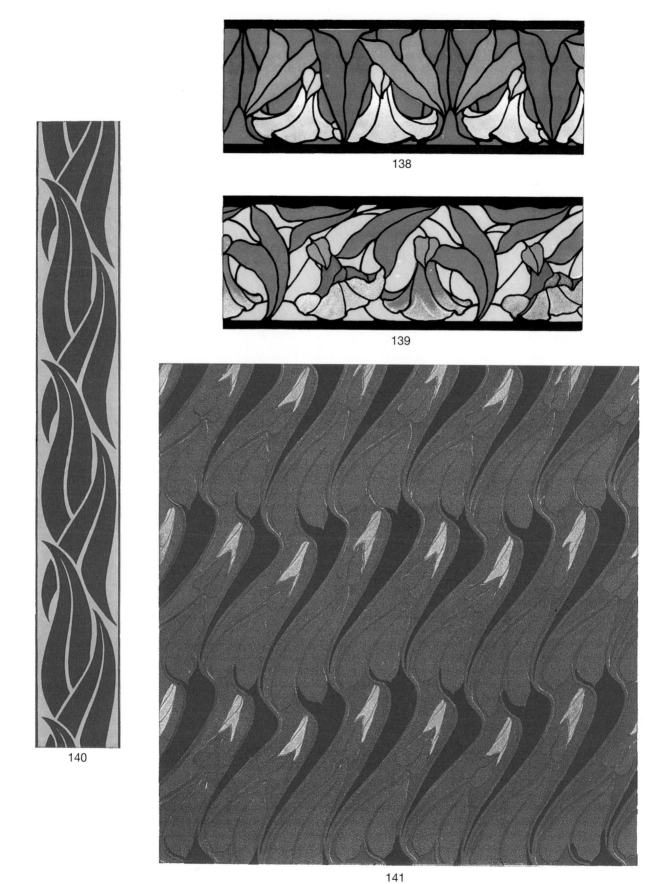

138

139

140

141

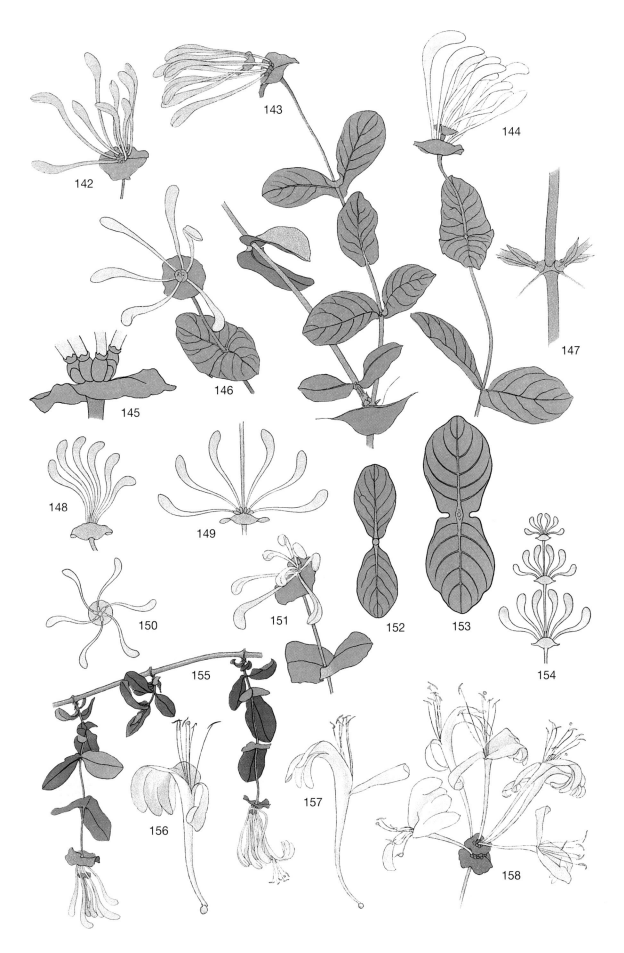

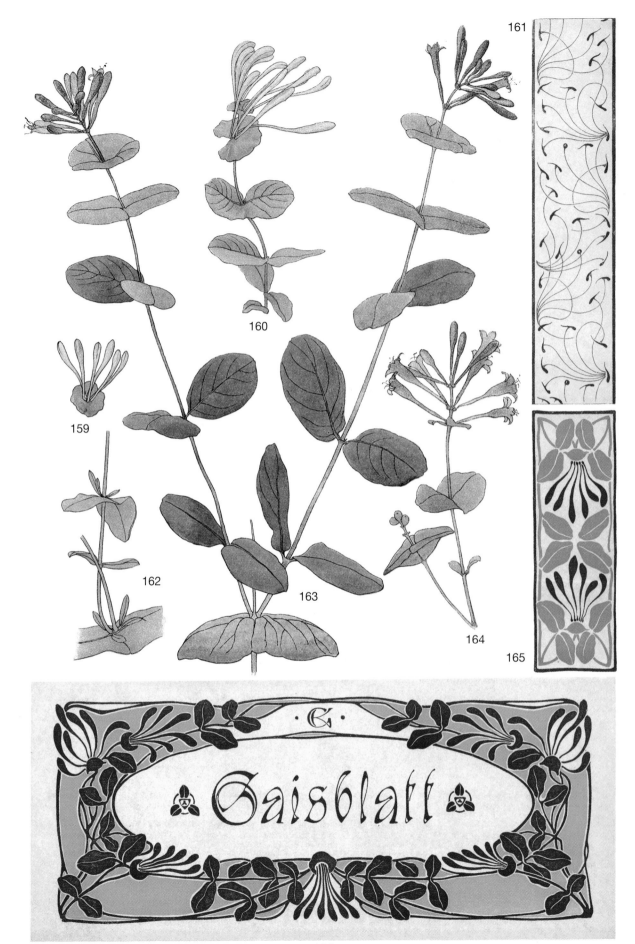

159

160

161

162

163

164

165

·G·

❧ Gaisblatt ❧

166

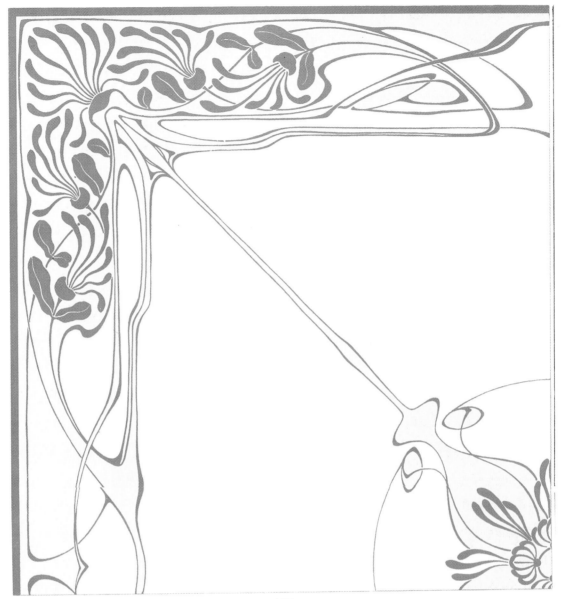

167

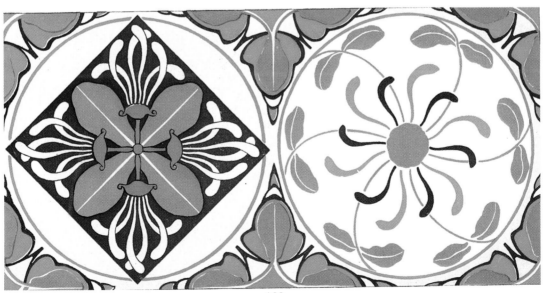

168

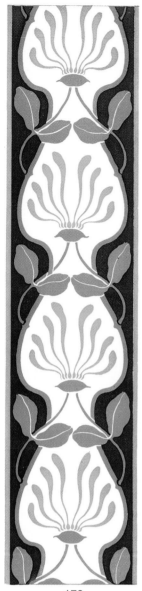

170

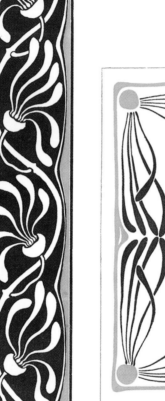

171

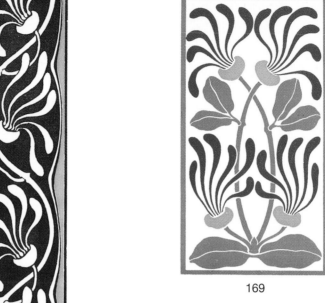

169

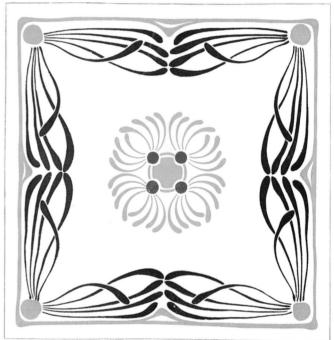

172

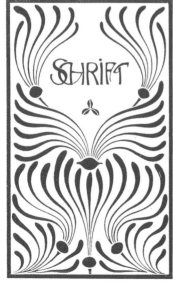

173

174

175

176

177

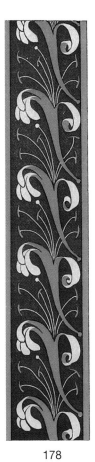

178

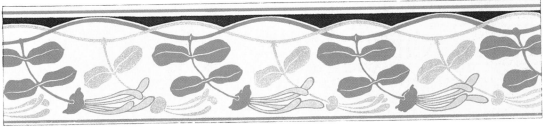

179

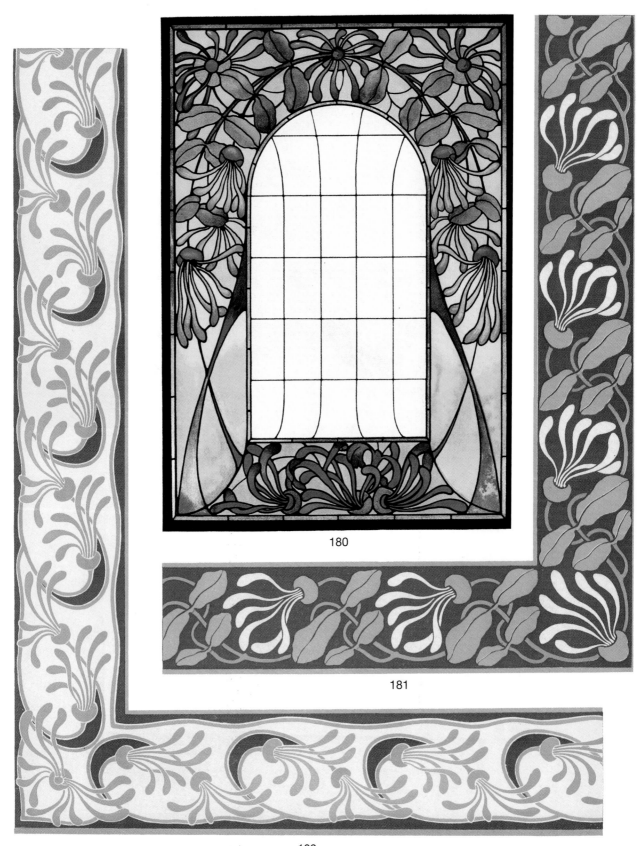

180

181

182

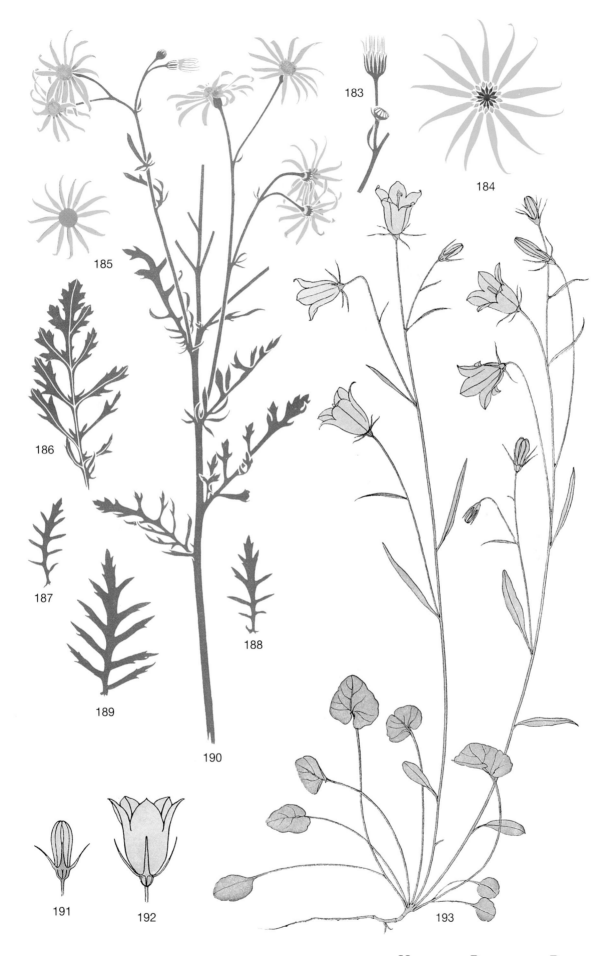

183

184

185

186

187

188

189

190

191

192

193

194

195

196

197

198

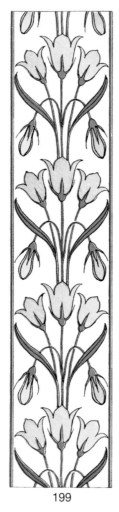

199

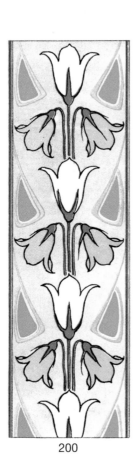

200

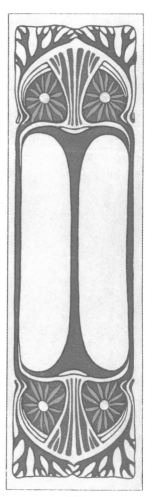

201

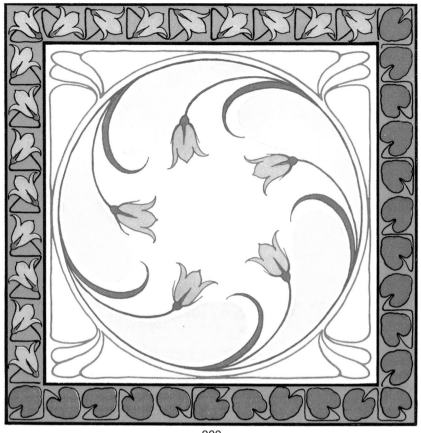

202

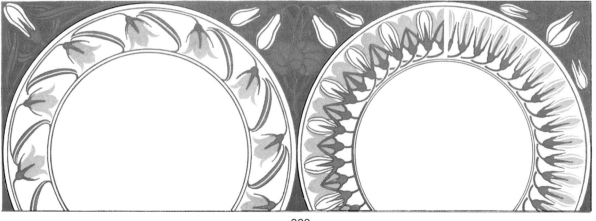

203

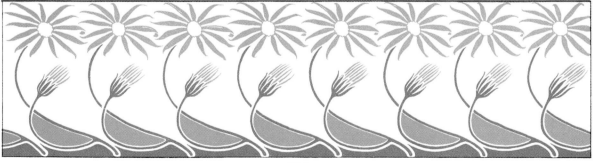

204

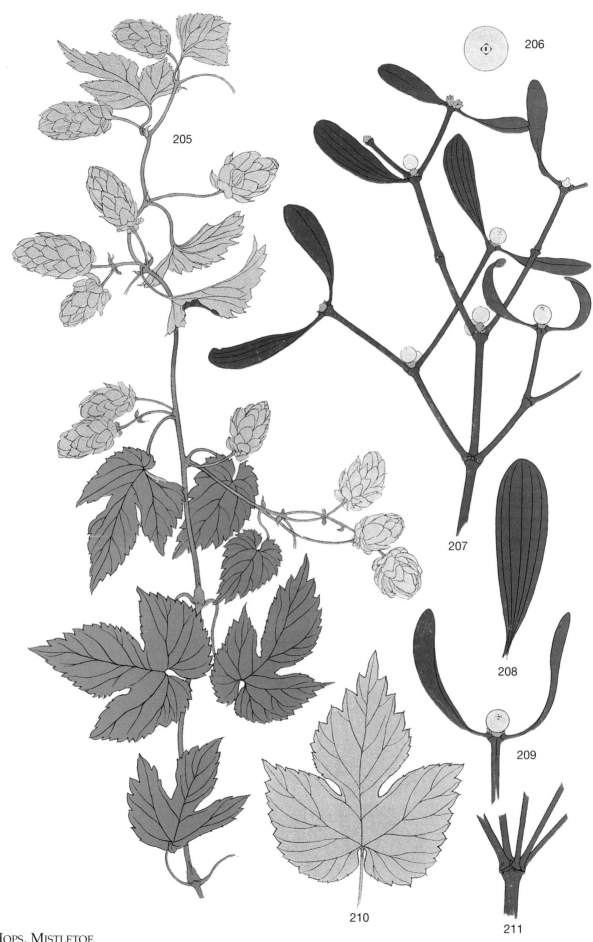

205

206

207

208

209

210

211

212

ZEICHENKUNST

DAS VERHÄLTNIS
DER KUNST ZUR NATUR

VON

PROF. DR. KONRAD LANGE.

·1902·

213

214

215

216

217

218

221

219

220

222

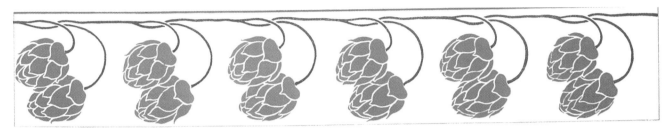

223

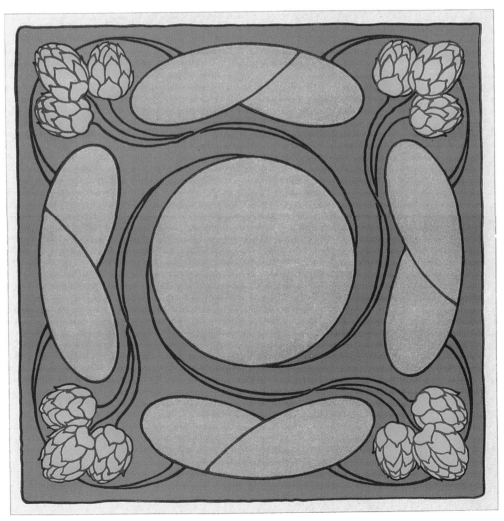

224

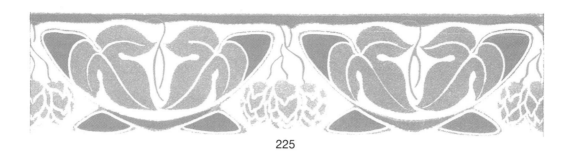

225

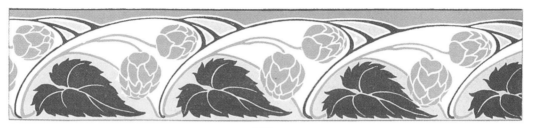

226

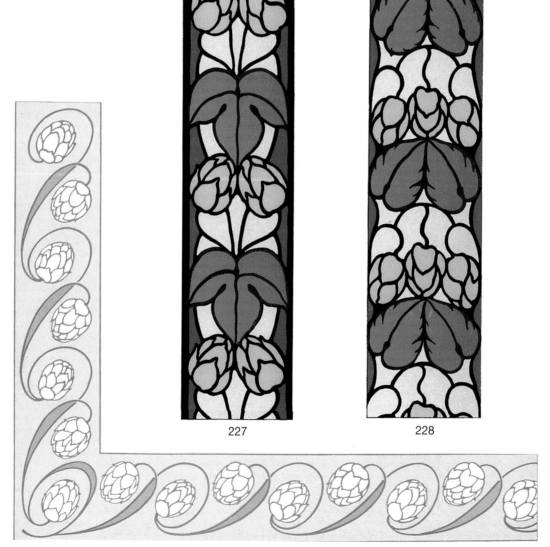

227

228

229

230

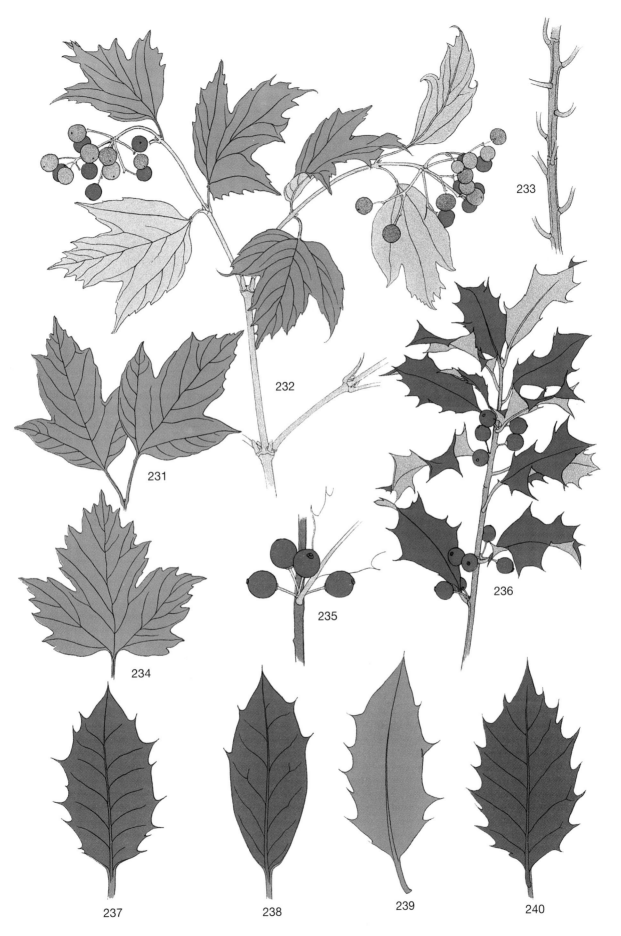

231

232

233

234

235

236

237

238

239

240

241

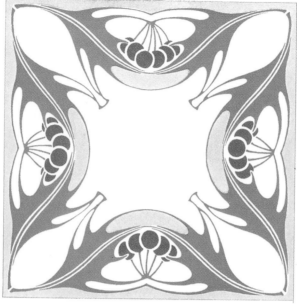

242

243

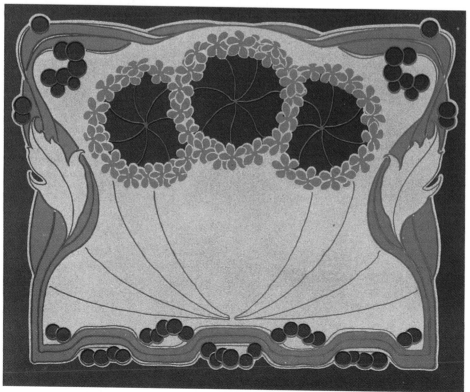

244

32 SNOWBALL BUSH, HOLLY

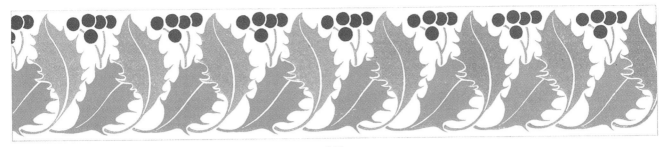

245

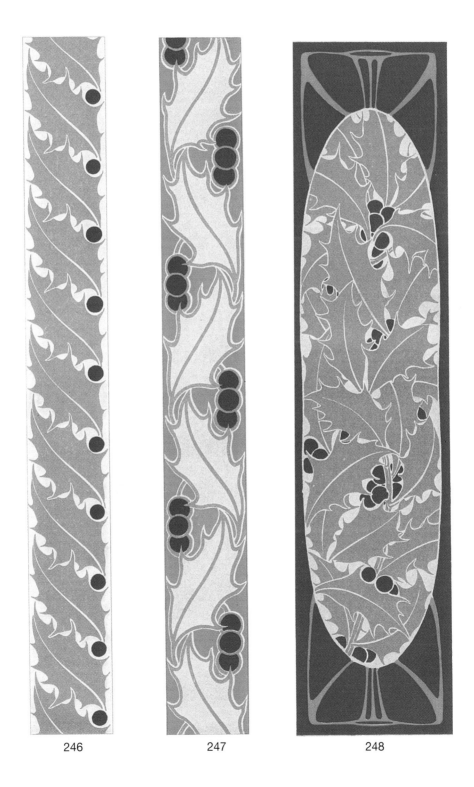

246 247 248

249

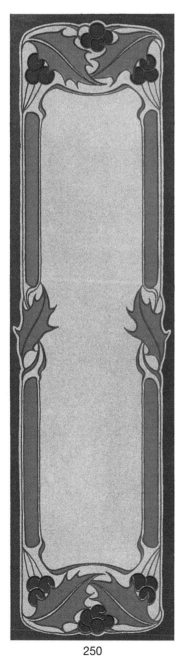

250

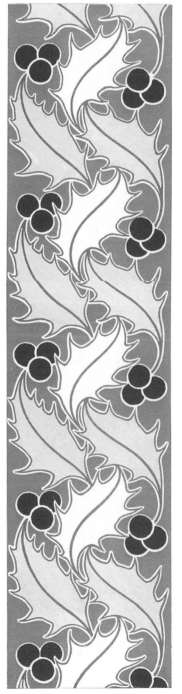

251

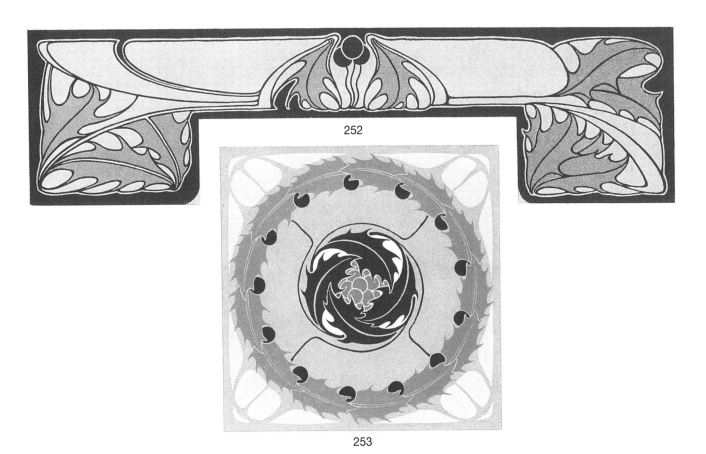

252

253

254

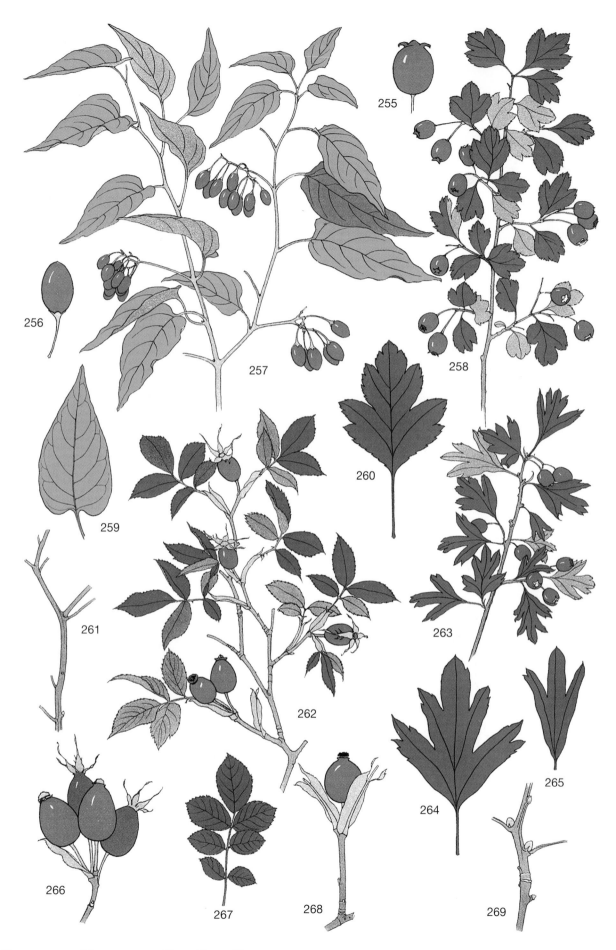

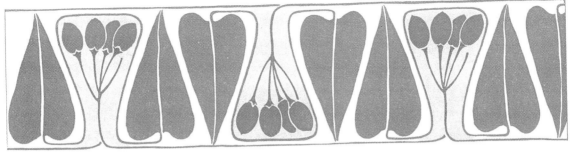

270

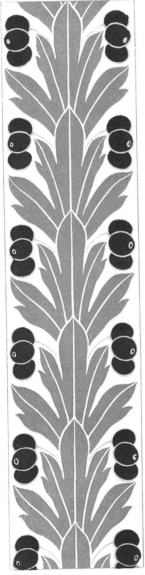

271

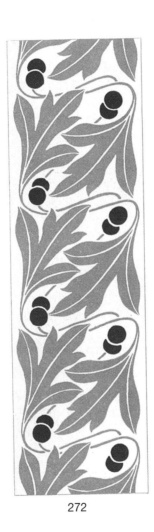

272

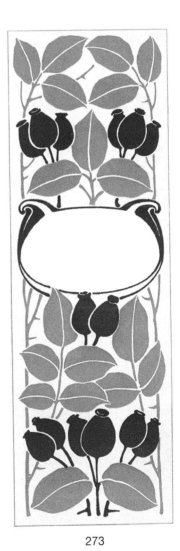

273

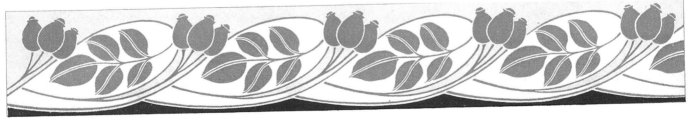

274

275

276

277

278

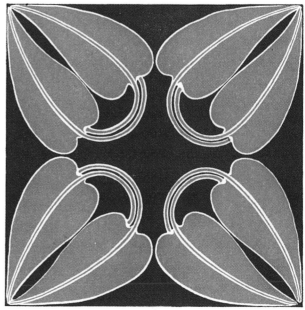

279

38 Bittersweet Nightshade, Rose Hips, Whitethorn

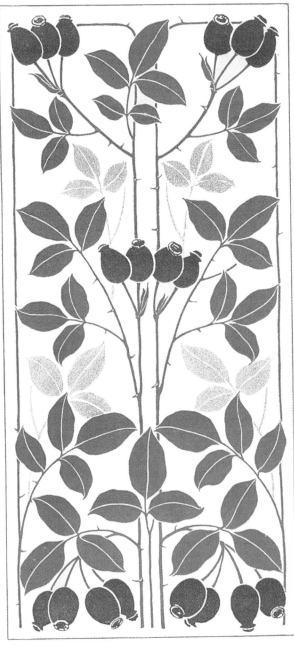

· UMRAHMUNG ·

280

281

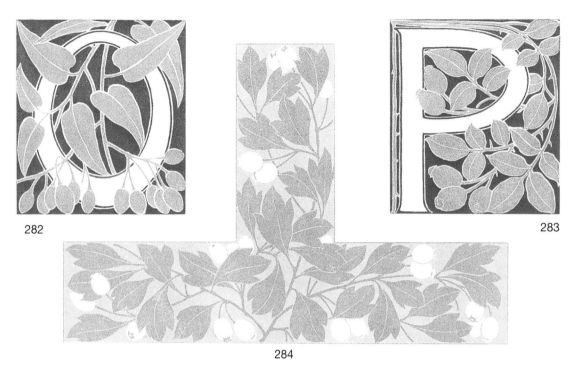

282

283

284

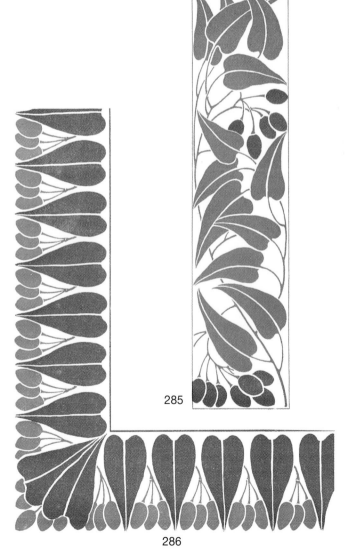

285

286

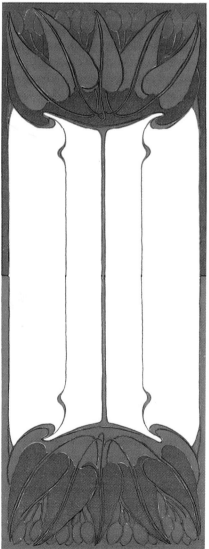

287

40 BITTERSWEET NIGHTSHADE, ROSE HIPS, WHITETHORN

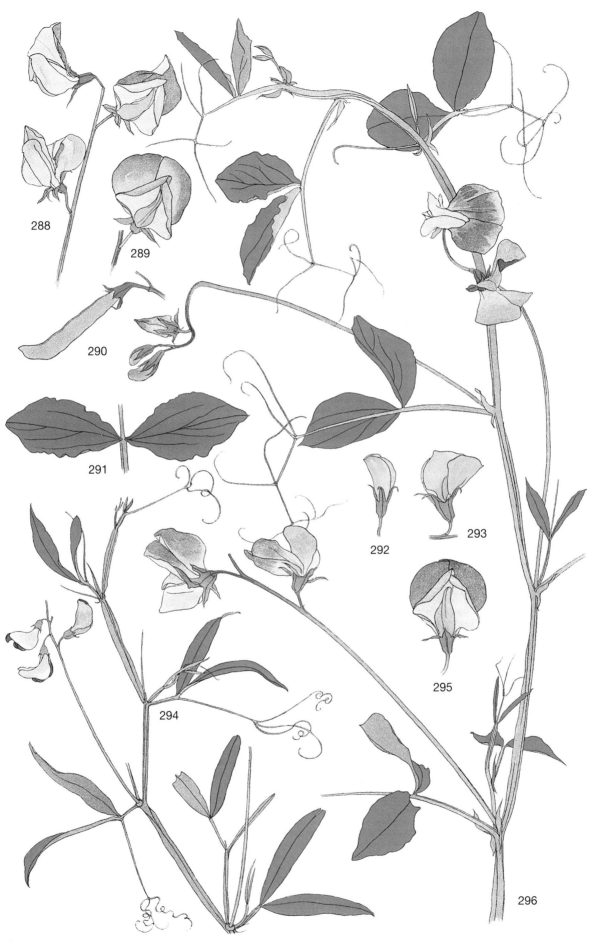

288

289

290

291

292

293

294

295

296

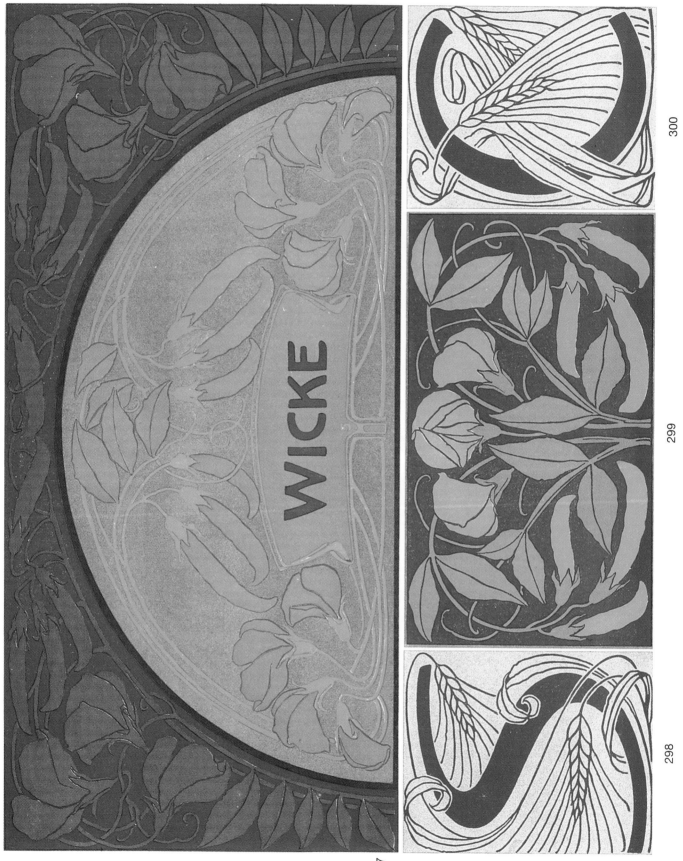

297

298

299

300

WICKE

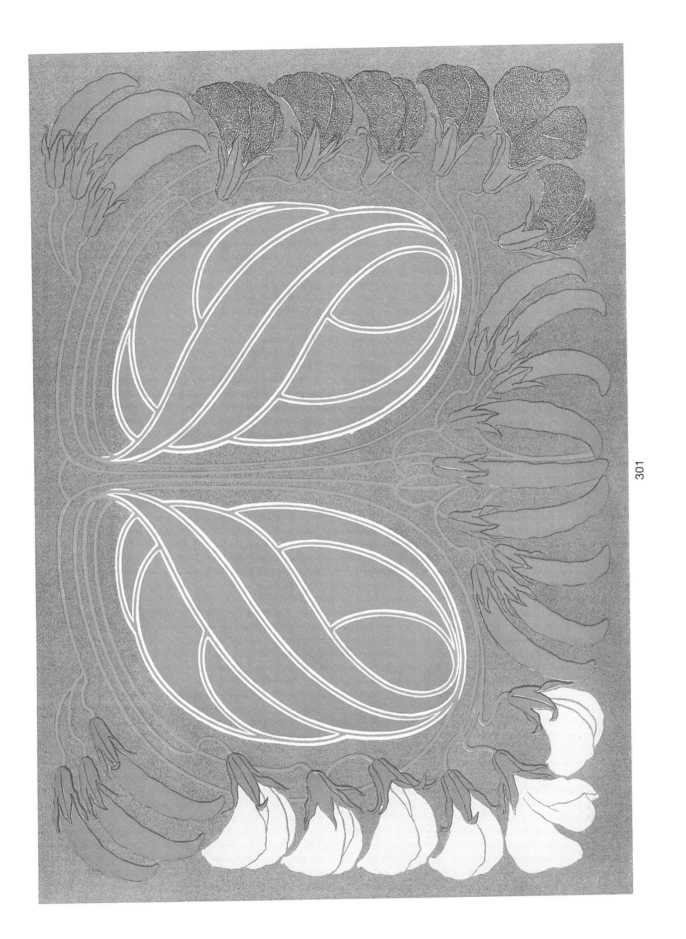

301

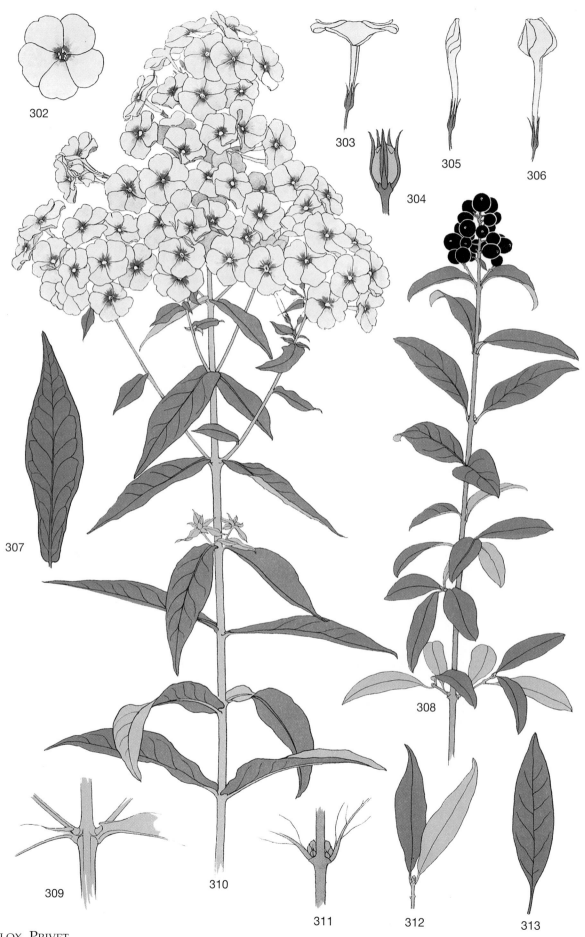

302

303

304

305

306

307

308

309

310

311

312

313

314

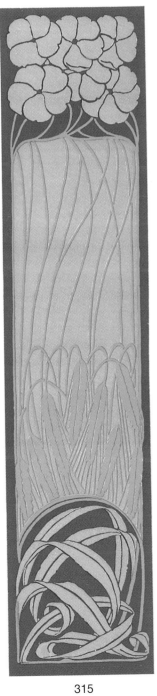

315

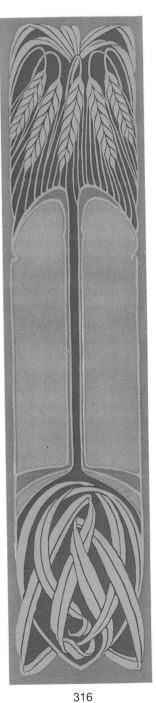

316

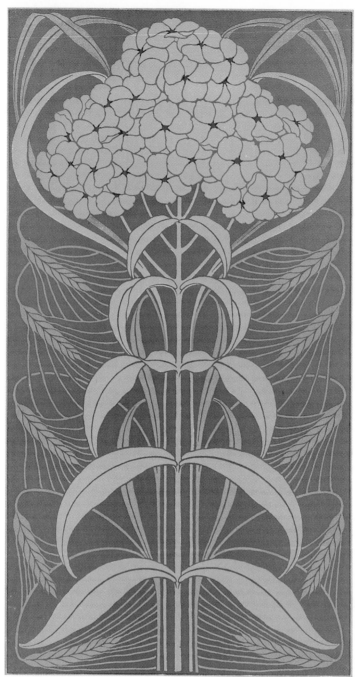

317

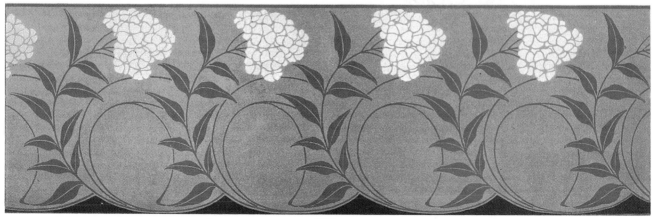

318